# The Long and Short Of the Round Oblong (Special Edition)

## Robert P. Clarke

The Long and Short of the
Round Oblong
First Special Edition
© Robert P. Clarke 2024

First Special Edition
ISBN: 9798327798359

Images ©Robert P. Clarke 2024

Other Books by Author

Life
Life: Blue Images
Life Cycling Images
Imagine Preview
Student Food Series One
The Other Room
The Less Abled Writer
Dancing with Ideas Around
an Imaginary Sculpture
Stride and Strife

For Carl

# Contents

Preface……………………….. 7
Poems…………………………. 11
Odd Shape……………………. 13
Juxtapose Me………………... 15
An Unusual Cocktail Party…….. 17
The Long and Short of It………. 19
Short Tall Round Oblong……… 21
Stories………………………… 25
The Arty Fox…………………. 27
The Philosopher and the Worm. 39

# Preface

The Long and Short of the Round Oblong is a poetry book with related stories that explores juxtapositions in the world of art, from shapes to distances to timings. The work is prepared for a performance piece at a drawing session taking place at Left Bank in Leeds on 10th June 2024.

The works, which are often humorous, will make the reader think about comparisons between different shaped objects, distances between objects and timings.

# Poems

# Odd Shape

There is an odd shape in the box
It doesn't quite fit in
All the others do
In their symmetrical alliance

This odd shape is called an artist
It started off as a square
And moved through the ranks
In its symmetrical awakening

One day this odd shape
Realised it wanted to be free
And it asked to be carved
Into an imperfect moving form

This form was called a figure
It stood there in the nude
Waiting to be given
Its clothing and many creative tools

This figure was so appreciative
For the creativity it had found
It wanted to give something back
So removed its clothes to pose
For other creative figures
To draw and sketch and learn

This artist was now a model artist
Creating many works
Providing creativity to everyone
And enjoying the freedom it deserved

# Juxtapose Me

Sharing stances
We lock for a brief moment
Separate, apart
Together, aligned
The distance between us
In our juxtaposed stance

The stillness of one
Reflecting upon the space
Remaining in situe
As the other one moves
Into a different flinch

The new scene is set
The change in pose
Sets off fresh ideas
From the moving set
Altering again,
In our juxtaposed stance

All is calm with the first statue
The view doesn't alter for them
As the second player moves around
Timely pausing
Reflecting in their stance
Then moving on
To the next location
In this set built for two

The process continues
In this unusual event
Where one statue remains grounded
While the other one changes pose
On and on this continues
Until the end
The viewers reflecting
On the players juxtaposed stance

# An Unusual Cocktail Party

I'm trying to imagine
A pickled egg on a stick
This would make sense
Of something short and oval,
Juxtaposed with something long

Then I got to thinking
How would this be received
At an upmarket cocktail party
Unusual as it may seem

It's not polite
To replace the olive,
Glazed cherry or berry fruit
With a pickled egg
On a stick
And a "fuck off" to you

But polite, isn't art,
So, I did it anyway
Plunged it in the sipping glass
And the cocktail splashed right out

The tuxedo was a little wet
And the drink left was hard to see
But at least there was comfort
That the pickled egg was ready to eat

# The Long and Short of It

The long and short of it is
There is a round object
And an oblong
Placed within a space
Juxtaposed for comparison

The long and short of it is
There is one timing that is long
And a timing that is short
With many small segments
To the same length of time
The long and short of it is
There is a distance between
One object and another
Placed within an area
And moved forwards and backwards

The long and short of it is
The measurement between
The objects change distance
While their stature stay the same
Juxtaposed all along

The long and short of it is
The comparison of the objects
For the viewer to reflect
Placed within a space
To allow juxtapositions to be made

# Short Tall Round Oblong

What are the inner boundaries
And what are the outer boundaries
Of short and Tall,
Of round and oblong

Well, it's a marriage, I proclaimed,
Where opposites attract
Yin and Yan
Meditate and work
While I consult a dictionary
Well pronounced and slang

Short and Round,
Tall and oblong
What do they make, I questioned?
A question mark, possibly?

No, I replied,
Tall and oblong
Short and Round
It's an exclamation
All the way!!!

# Stories

# The Arty Fox

I was sat in the bar drinking a pint of 'Round Short Smooth Oblong'.  It was a best bitter, although I likened it to an IPA, because it had the strength and depth, while at the same time was smooth, but with a delicate hoppy flavour.  It was stronger than most best bitters.

The pub felt traditional, but its contemporary fresh burst of decor suggested that it was actually neo-traditional. It wasn't a theme pub, but it did feel very arty. I suspected the landlady had once been part of the art scene in the past, whether it be the 1960's where all the performance happenings had been taking place, the 1970's where there was a surge of new media or

the 1980's looking back to modernism in a post-modern era.

The landlady certainly wasn't part of the Brit Pop era of the 1990's or part of the neo-realists from the era before that in America.

When I went up to the bar next, I made a point of asking her about a 'Reverse Bungee Jump' and if I could try a 'Pogo Stick' later, briefly also asking her if she was an artist, and if so, what type of art she produced.

I'd never heard of the cocktails the 'Reverse Bungee Jump' or a 'Pogo Stick' before.

I noted them down to make a point of asking my student house mates when I got back later, if they would like

to share a 'Reverse Bungee Jump' with me or possible try a 'Pogo Stick' with me instead.

Anyway, the landlady replied that her mother had been born in the late1940's just after the war and was very much a part of the swinging sixties, her mother had met a boy at a hypnotic happening art party and that she herself had been born in the 1970's an era of change.

My own experiences were similar, although rather different in one or two ways. My parents had been born an era earlier in the 1920's and 1930's, so they had both lived through and experienced World War II at first hand. They had met at work on the buses in the 1950's, my older brother and sister were born in the

1960's and I was a happy accident in the late 1970's.

I continued on talking to the landlady about my life.

So, my first degree was in the late 1990's and here I was now studying an MA in the mid 2020's, living in a student house with a mixture of BA and MA students, all like-minded people.

Thomas was studying a degree in Soap Opera studies, and his life really was a soap opera.

Cherry met Thomas at a Twin Peaks convention and they hit it off straight away. Cherry was studying some weird science that nobody else had ever heard of, so I don't usually check any further than that.

It was a bit of joke really, they were both madly in love with each other and you could hear them making love screaming loudly at every possible moment they could, but they'd also have furious arguments together too, screaming loudly at each other at every possible moment. We simply called them 'Tom and Cherry, they'd love together like cat and mouse and play fight together like cat and mouse too.

Paul was a studious type, he would always come home late, go to his room and set off first thing in the morning. I think I've only seen him once, and that's when he had diarrhea. I thought he was a new housemate at the time.

Then finally Ward, now she was a party girl, loved her liquor and was a person I could really relate to, but equally so, she was hard working, and devoted her time to achieving at the highest possible level.

When I got back to the house I asked my housemates, would you like to share a 'Reverse Bungee Jump' with me or possible try a 'Pogo Stick' instead.

Ward was definitely up for it. I'd be drinking them with her later. Paul said he was already working on the thesis of relativity and went back to his room to consult his notes and take the

cocktail recipes to laboratory test them at his own mini bar in his room.

Tom and Cherry simply said they'd already had three 'Reverse Bungee Jumps', and two 'Pogo Sticks' earlier in the day and they were about to move on to a 'Pickled Egg on a Stick', although I don't think they were talking about drinks.  From the grunting noises they were making in their room later, it sounded like they were having a good time.

The landlady's name was Jan.  Apparently, she'd been born in January and was a Capricorn, whatever that means.  Jan had worked in the retail industry for many years, firstly in shops, then in the hotel industry before becoming the landlady at this inviting bar.

It turned out the pub was called 'The Foxy Dodger', I hadn't really noticed when I'd walked in. I'd struck up quite a conversation with Jan, she was particularly interested in my life in relation to hers. I too, being an artist, loved juxtapositions and comparisons.

It's what makes us think and reflect on the wider whole.

Anyway, we exchanged numbers and I said I would call her later in the week so that we could maybe meet up and chat more over a drink or two, possibly participate in a 'Pogo Stick' together or share a 'Reverse Bungee Jump' with me.

One thing was left burning on my mind on exiting The Artful Fox (I'd obviously already forgotten the name

of the pub), the real question been, why was the 1970's an era of change, and then I realised walking home, it was the era both Jan and I were born, a personal liberation, this was an era about 'Me', this was an era of counterculture and a continuation of rejecting social norms and traditional norms.  This was the era where we could make a change.
The ultimate changes...

After all, the cycles of life are repetitive, aren't they.

# The Philosopher and the Worm

"What is a round oblong?", Granger asked Gray.

Granger was very intellectual. He was a learned man with as much practical sense, as much for his knowledge of the wider world.

Gray pondered this question posed before replying. Gray was the 5th Earl, of the 6th Regiment, of the 7th Battalion, of the 8th Corps, of the 9th Region (that could not be named).

In other words, nobody knew who the fuck Gray was, but he sounded important, which was the main thing... and also, he employed a valet.

After pondering a while, Gray responded.

"It's like this, if I want a long tall drink, I would expect it to be served on a round silver tray" Gray said slowly. Granger raised his eyebrows in response.

"Yet, I do serve your drinks in long tall glasses on round silver trays, already" Granger replied. "Of course, but that was just an example." Gray continued. "I'm also thinking of an automobile, which is oblong, yet the wheels are round, what do you surmise, Granger, is that the correct answer to your question?"

Granger didn't know what to say.

"Of course, that was just another example." Gray continued. "I was actually thinking the other day when we were mingling at the Highbury's ball in the evening, and I saw the hosts from across the room, one was small and well pronounced and the other was tall and thin."

"Small and Round, Tall and Oblong" Granger filled in the gaps. "And it is a partnership, a possible juxtaposition, sir?"

"It just got me thinking, that's all" Gray said while accepting another drink in a tall glass on a silver round tray.

"Are you thinking about the next portrait of yourself, sir?" Granger enquired.

"No, the artist tells me how to sit" Gray replied "I was just thinking."

"But, you are taught, sir. You, are taught." Granger smiled at Gray and paused. "It's time for your night cap, sir. Would one like a cognac tonight"

"Yes, make it a double, old chap" Gray responded. "It'll help me not to think."

"That's the correct answer to the question" Granger replied, "I've already prepared your room for the night."

www.ingramcontent.com/pod-product-compliance
Lightning Source LLC
Chambersburg PA
CDIIW070141230526
45472CB00004B/1638